# Landscapes in Watercolour

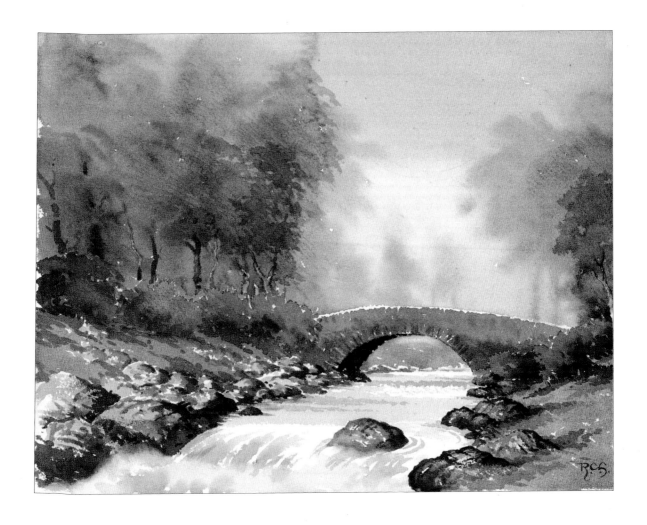

To my family, my friends, fellow painters and all those who share my love of pure watercolour.

# Landscapes in Watercolour

## RAY CAMPBELL SMITH

SEARCH PRESS

First published in Great Britain 2000

Search Press Limited
Wellwood, North Farm Road,
Tunbridge Wells, Kent TN2 3DR

Reprinted 2001, 2002, 2003, 2005, 2006, 2007

ISBN 10:  0 85532 849 5
ISBN 13: 978 085532 849 8

The Publishers and author can accept no responsibility for any
consequences arising from the information, advice or instructions
given in this publication.

The publishers would like to thank Winsor & Newton for
supplying many of the materials used in this book.

**Suppliers**
If you have difficulty in obtaining any of the materials and
equipment mentioned in this book, then please visit the Search
Press website for details of suppliers: www.searchpress.com

Alternatively, you can write to the Publishers at the address above,
for a current list of stockists, including firms who operate a mail-
order service, or you can write to Winsor & Newton requesting a
list of distributers.

Winsor & Newton, UK Marketing
Whitefriars Avenue, Harrow,
Middlesex, HA3 5RH

**Publishers' note**  All the step-by-step photographs in this
book feature the author, Ray Campbell Smith,
demonstrating how to paint landscapes in watercolour.
No models have been used.

There is a reference to sable hair and other animal hair
brushes in this book. It is the Publishers' custom to
recommend synthetic materials as substitutes for animal
products wherever possible. There are now a large number
of brushes available made from artificial fibres and they are
just as satisfactory as those made from natural fibres.

*I should like to acknowledge the invaluable professional
help I have received from Roz Dace, Editorial Director,
and Chantal Roser, Editor. I also wish to thank
Susannah Baker for converting my scrawl into perfect
typescript and, as ever, my wife Eileen for her unfailing
encouragement and support.*

*Page 1*
**The Old Stone Bridge**
*430 x 330mm (17 x 13in)*

*Pages 2–3*
**Bend in the River**
*370 x 280mm (14½ x 11in)*

*Opposite*
**Tower Bridge**
*375 x 285mm (14¾ x 11¼in)*

# Contents

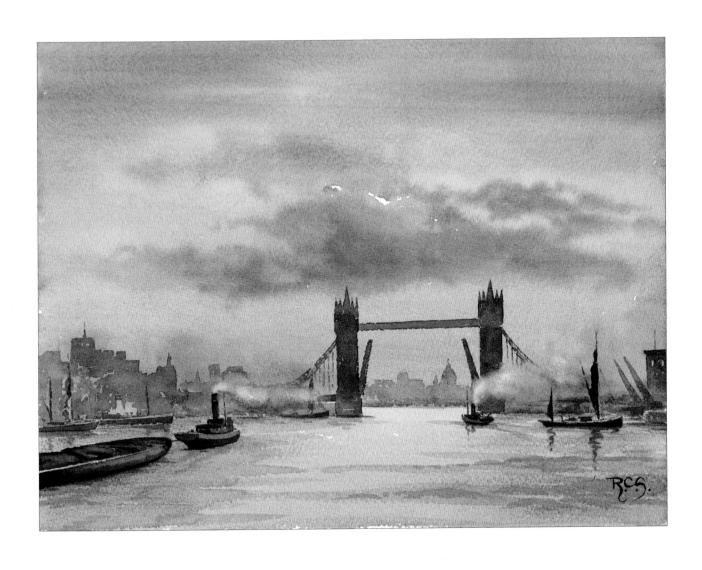

# Introduction

Watercolour is generally considered the most difficult of all the media and it is this unenviable reputation that deters many artists from accepting its challenge. Despite the difficulties, which experience and practice can overcome, watercolour has unique qualities which cannot be matched by any other medium. Correctly applied, watercolour has a freshness and a beauty which comes close to capturing the glow and subtlety of nature itself. It is perhaps at its best when used with skill and imagination to suggest the atmospheric effects of misty landscapes, as Turner's matchless watercolours testify. The capacity of the medium to portray light is only realised by artists who have learnt to convey their message in fresh, simple washes, and to say what they have to say in one telling wash rather than in two or more. This quality of freshness is all too easily lost by overworking, by alteration and by labouring after detail. Then dullness and muddiness rear their ugly heads and the beauty of the medium is lost.

Perhaps the most common fault of all is over-preoccupation with accuracy, with trying to paint the scene precisely as it is in every detail. This usually involves altering applied washes to make them match more exactly the tones and colours of the subjects depicted, and adding laborious detail. What must you do, then, to avoid dullness and

*Mountain Reflections*
*550 x 375mm (21¾ x 14¾in)*

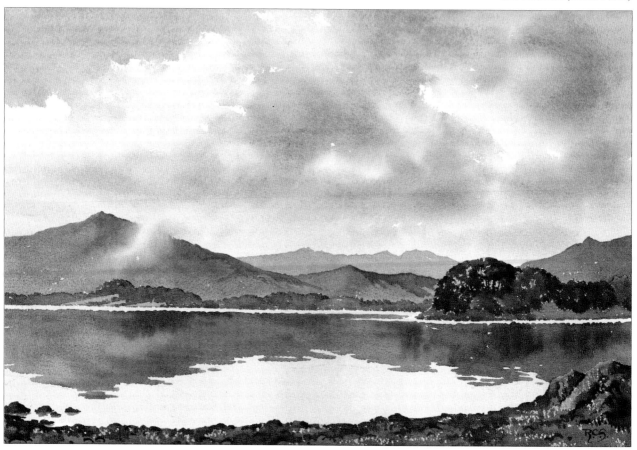

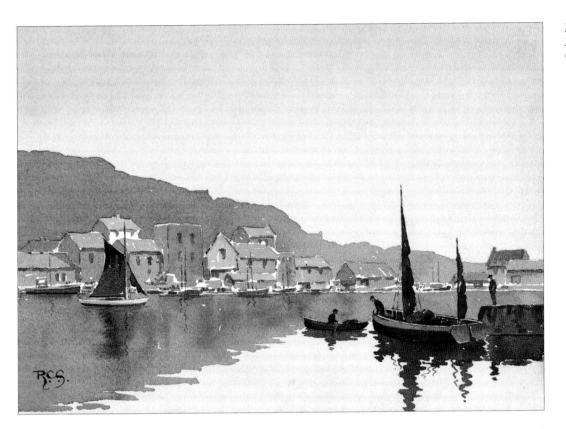

*Fishing Village*
*380 x 270mm*
*(15 x 10½in)*

muddiness? Happily there are watercolour techniques which enable you to capture the form and texture of your chosen subjects in a fresh and painterly way and it is these I shall be examining and getting you to practise in this little book. True, they do not enable you to describe your subjects in every last particular – the camera can do that – but they do enable you to capture their character and their essence, and this should be the aim of every watercolourist. Here, then, is what you should do:

• Simplify the scene before you and ignore irrelevant detail so that you can describe your subject in bold, free washes. Never paint straight from the pan but always prepare a wash (a little puddle of well-mixed paint and water), however small the passage involved. Eschew tiny brushes whenever you can – a bigger brush will help you make bold, confident statements.

• Until you are more experienced, try out your washes on scrap paper first, to make sure they are right for colour and tone, before applying them to your watercolour paper. This may well save you from having to alter them in your painting, thereby losing freshness.

• Avoid too many colours in one wash – three should be your maximum. Avoid, too, using doubtful residues of leftover washes for the same reason. Your object should always be to let the paper shine through transparent washes.

• Even if your painting does not accurately describe your subject, resist the temptation to make corrections. What you gain in precision you will more than lose in freshness and spontaneity. We all wonder, on occasions, whether we should add that final extra touch or detail. My advice is don't!

These are the principles you should apply when tackling the landscapes featured in the following pages. If you bear them in mind when you are attempting the same subjects for yourself, I am quite sure your work will benefit greatly and you will succeed in preserving the transparent beauty of the medium, to achieve fresh and glowing results.

# Planning and composition

Planning and composition are essential to successful watercolour painting. In this context, composition simply means the arrangement of the elements of your chosen subject on the paper in such a way that the overall effect is pleasing and harmonious. This is not quite as easy as it sounds. There are a number of all too common faults you should be aware of if you are to achieve attractive and well-balanced compositions. Here are some ways of avoiding these common errors.

• Never cut your painting into two equal halves, either horizontally (perhaps by placing the horizon exactly half way up the paper), or vertically (by placing some dominant vertical such as a church spire too centrally). Move the horizon down if the sky is an interesting one, or up, if you are more interested in the scene below. Move the dominant church spire to the right or left and then balance it with some other feature.

• Avoid having all the tonal weight on one side of your painting – it can usually be balanced by placing a dark tree or heavy cloud on the other side. Be aware of this danger and then use your ingenuity!

• Try to include tonal contrasts – the placing of lights against darks and darks against lights. You can use a little artistic licence to achieve this, for instance, by moving a dark copse behind a group of pale-toned cottages.

• It is always a good plan to have a focal point or a centre of interest in your painting, a point to which the eye is naturally drawn. If you can arrange some of the main construction lines of your composition so that they help to lead the eye to this focal point, so much the better. Avoid having two competing focal points – the eye will move from one to the other and find nowhere to come to rest.

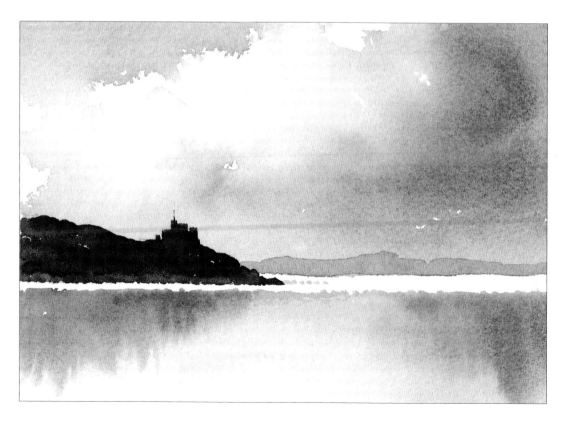

*Castle on Headland*
*185 x 135mm (7¼ x 5¼in)*

*Here the tonal weight of the castle on its promontory is balanced by the heavy cloud on the right and its reflection.*

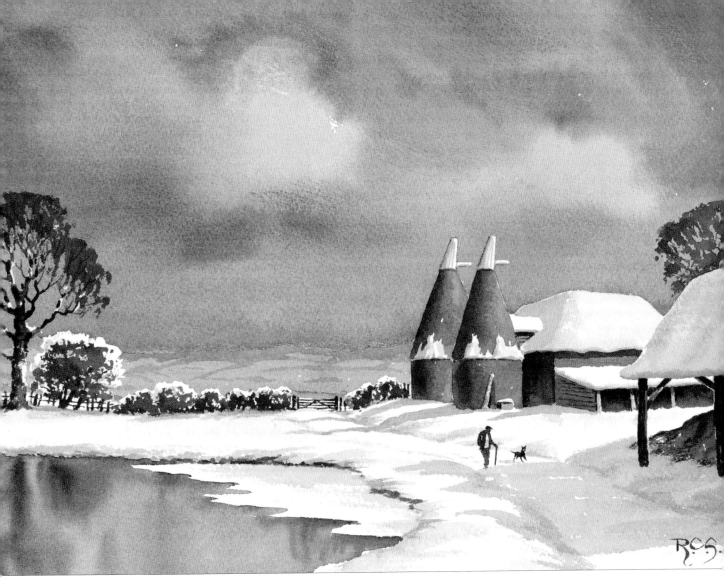

**Wealden Farm in Winter**
*365 x 270mm (14¼ x 10½in)*

*The farmer and his dog provide human interest as well as a focal point. The line of the farm track carries the eye towards them and the shape of the foreground snowy roof points directly at them.*

• If your composition includes any moving objects, such as horse riders or sailing boats, make sure you have them moving into your painting rather than out of it, so that the eye of the beholder is also drawn into the heart of your painting.

• Features such as roads, tracks, rivers and streams can easily carry the eye straight out of the painting. In these instances, it often pays to use a building, a group of trees, or some other object as a blocking device.

• Avoid what is sometimes referred to as the 'coincidence of unrelated lines'. For example, if the roof line of a foreground building is exactly in line with the horizon, correct it by either raising or lowering the offending roof.

Avoiding faults is a necessary if rather negative process. A more positive approach is to study the paintings of accomplished artists and work out for yourself why you find their compositions pleasing and attractive.

9

# Materials and equipment

The following materials are my choice but they are not necessarily the best for your particular style of painting. Experiment until you find which suit you best.

## Paints

I believe firmly in the advantages of the limited palette – a narrow range of colours which you can get to know really well – and advise beginners to avoid large and expensive paintboxes with dozens of different colours. A small one with plenty of mixing space is all you need. For more information about choosing colours, see pages 12–15.

There are two further choices to be made – should you opt for tube or pan paint, and for students' or artists' quality paints? I prefer tube colours for their more liquid form and their greater responsiveness. Before starting a painting I squeeze generous amounts of the colours I shall require into the appropriate pans in my paintbox. The new paint freshens up the old and there is no waste. If you use pan colours, add a few drops of water to them from time to time to ensure that they are kept reasonably soft (nothing is more damaging to brushes than using them to coax reluctant pigment from dried up pans).

Artists' quality paints are more brilliant and transparent than students' quality and I believe they are worth the extra cost. Watercolourists do not use up paint with the gay abandon of painters in oils or acrylics, so they should last a while. In recent years I have tested and reported on paints from many different countries for art magazines – watercolours from Russia, Denmark, Germany, Holland, Italy and Spain – and some of them were excellent and keenly priced, so it pays to shop around.

## Brushes

It is well known that Kolinsky sable watercolour brushes are the best that money can buy, for their spring, their wash-holding properties, their durability and their all-round quality. Unfortunately they have become so expensive that most artists have to seek alternatives. There are some excellent ones on the market, at a fraction of the price of sable – some wholly synthetic, some a blend of sable and synthetic.

Choosing the correct size can be difficult. You will need at least one large brush for dealing with broad areas such as skies. The actual size will depend upon your scale of work but I would suggest a 25mm (1in) flat or a similar sized mop. I use three large brushes for painting skies so that I can deal with the sunlit areas of clouds, the cloud shadows and the blue sky without having to clean brushes between washes, but you can manage with just one. In addition, I suggest you have three rounds – a No. 12, a No. 8 and a No. 4, plus a rigger for tackling fine lines. As you become more experienced, you will no doubt add to these basic few, but they will serve you well to begin with.

# Paper

With watercolour paper, I come down firmly on the side of quality, despite the extra expense. You will find that a good quality rag paper will really flatter your work!

Weight is also important. The lighter papers – 190 and 300gsm (90 and 140lb) – cockle excessively when liquid washes are applied, creating all sorts of difficulties. However carefully you apply them, your washes will run off the ridges and collect in the valleys. This results in uneven drying which in turn causes cauliflowering and other problems. These lighter watercolour papers should be stretched to prevent them from cockling.

Paper comes in three types of surface, though these vary considerably between different makes: smooth (HP for hot press), Not (CP for cold press) and rough. I generally favour rough for landscape work as it facilitates techniques for conveying texture and capturing the broken outlines of foliage, but Not papers are also suitable and pleasant to use.

I buy my watercolour paper in 760 x 560mm (30 x 22in) sheets and cut it either into two – 560 x 380mm (22 x 15in) – or four – 380 x 280mm (15 x 11in). It is well worth experimenting with different makes and surfaces until you find one that really suits you.

### Stretching Watercolour Paper

In general, any paper under 425gsm (200lb) should be stretched to avoid cockling. To do this, immerse the paper in clear water for about five minutes, then pick it up by one corner and lay it on a flat surface such as a painting board. Carefully smooth away any air bubbles with a soft cloth, remembering that the paper surface is particularly vulnerable when wet. Finally, tape around the edges with gummed paper strip (not masking tape) and leave overnight. The paper should be dry, tight as a drum and ready for use the next morning.

## Etceteras

You will need a light easel for working in the field unless, as I do, you prefer to have your painting board on your lap, so that you can move it around to encourage the flow of your washes. A light folding stool will be needed if you prefer to work seated. A viewfinder, a small paintbox, an extra mixing palette, a water container, a paint rag or tissue, a 2B pencil, a soft eraser, a pen knife and insect repellent to keep the midges at bay can all be conveniently carried in a haversack or something similar.

There are also a variety of optional aids, such as masking fluid and tape (useful means of preserving the white of the paper where necessary), scalpels for scratching out highlights and so on. These should be handled with restraint and discretion or the result becomes tediously artificial.

# More about colour

With experience, your own limited palette will gradually evolve, but until that happy day it is not a bad idea to adopt the range of colours of an artist with whose work and style you are in sympathy. My limited palette for landscape work consists of raw sienna, burnt sienna, light red, French ultramarine, Winsor blue and Payne's gray. To this list I sometimes add alizarin crimson and the umbers, while for sunnier climes I often add cadmium yellow and cadmium orange.

Ready-made greens often look artificial, as they contain too much blue. Many painters prefer, as I do, to mix their own. I find raw sienna with a touch of Winsor blue is excellent for meadow grass, while for a brighter green (perhaps for the lusher grass of garden lawns), cadmium yellow, instead of raw sienna, does the trick. For dry grass or hay, raw sienna with a little French ultramarine is about right. If you prefer to use a ready-made green I would suggest olive green is about the most natural for grass and foliage, but even this usually needs a little added yellow.

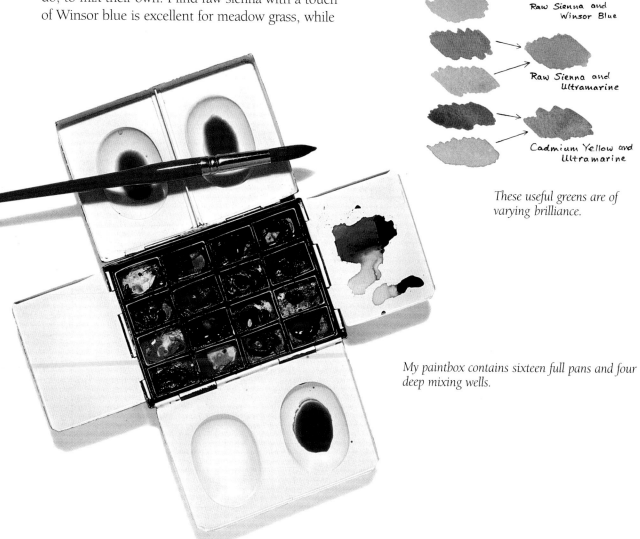

*These useful greens are of varying brilliance.*

*My paintbox contains sixteen full pans and four deep mixing wells.*

The true beauty of watercolour lies in its freshness and transparency. Washes should be prepared and applied correctly in order to preserve these precious qualities. Because it is a clear medium, at its glowing best when the paper shines through the applied washes, you should avoid anything that compromises this transparency, such as the use of opaque body colour. It is tempting, if you have failed to make provision for highlights, to resort to Chinese white, but in my view this has a somewhat chalky appearance and cannot match the shine of untouched paper.

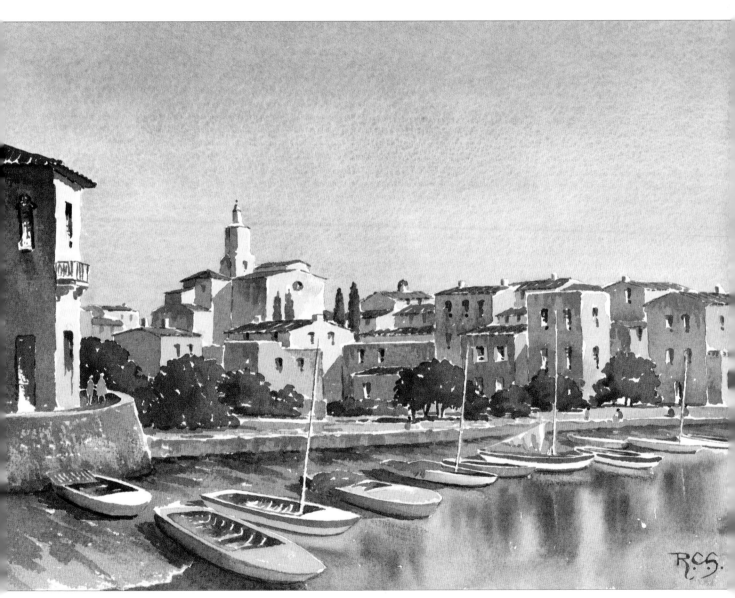

*Cadaques, Catalonia*
*380 x 275mm (15 x 10¾in)*
*A bright palette is used to capture the colours of this Mediterranean scene.*

Masking fluid and masking tape can be used to preserve areas of pale tone. Masking fluid is a form of liquid latex which can be applied with a brush or pen to the areas to be protected. Masking tape is useful for protecting larger areas.

Masking fluid should be left to dry before being painted over. When the applied wash is completely dry, the latex film can easily be rubbed off to reveal the pristine white paper beneath. Two words of warning here: firstly, ensure your watercolour paper will stand up to its use (with some of the softer papers, surface fibres will come away with the dried latex); secondly, however carefully you wash your brushes immediately after use, masking fluid does ruin them, so use only cheap brushes or those that are due to be pensioned off.

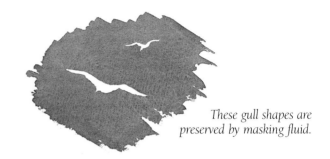

*These gull shapes are preserved by masking fluid.*

***Tea in the Garden***
*330 x 245mm (13 x 9¾in)*
*Masking fluid is useful for retaining areas of white paper. Here, it was used to preserve the sun umbrella, the figures and the garden furniture.*

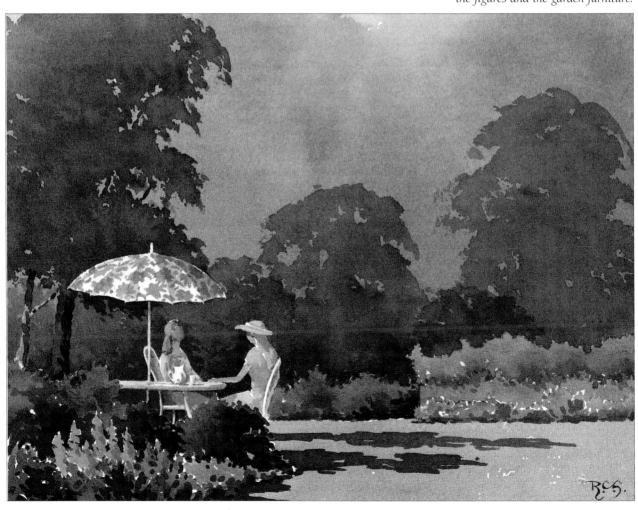

*Devon Cove*
*370 x 280mm (14½ x 11in)*
*Bright, contrasting colours add significance to these two tiny figures.*

There are two very effective ways to make your colours shine, in addition, of course, to preparing and applying your washes correctly. Firstly, if you place a dark object beside a light one, the contrast will make the lighter colour appear to glow. In the accompanying sketch, the white cottage has been placed against a dark shoulder of mountain and consequently stands out dramatically by contrast.

The other way to make your colours glow is to place complementary colours (those exactly opposite each other on the colour wheel) close together. Notice how the red figure in the sketch stands out against the predominantly green background.

*This red figure registers*
*strongly against the*
*complementary green setting.*

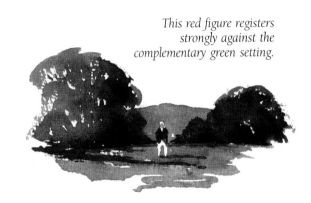

*This white building*
*stands out against*
*its dark mountain*
*background.*

# Getting started

Most landscape artists rightly prefer to work in the field, drawing their inspiration direct from nature. Those lucky enough to live in areas of outstanding natural beauty have an obvious advantage, but it is worth remembering that the subject of a painting is of far less importance than the skill and understanding with which it has been painted.

Choosing a pleasing composition from a broad sweep of country can pose problems and this is where a viewfinder can play a useful part. In its simplest form this is just a piece of card – perhaps an off-cut of mounting board – with an aperture cut in it of roughly postcard size. You simply hold this up to the scene in front of you and move it around

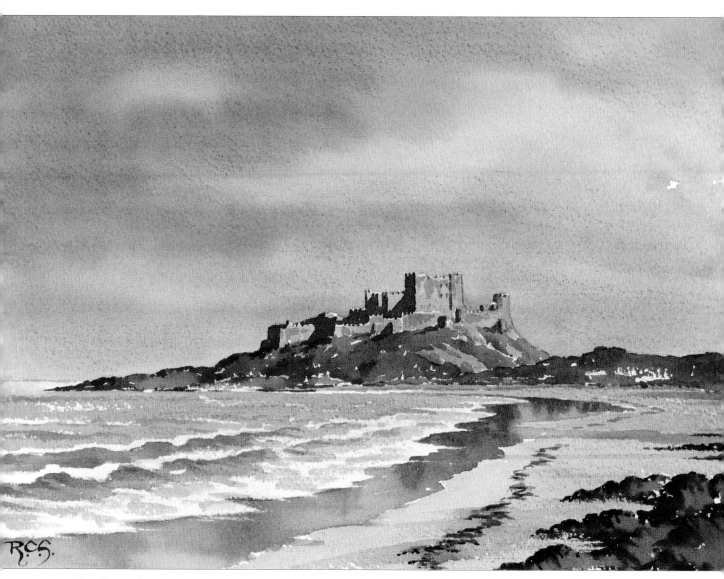

*Bamburgh Castle*
*375 x 270mm (14¾ x 10½in)*
*Strong lateral light here adds greatly to the drama of the subject.*

until it frames a section of the view that you feel makes a pleasing composition. Naturally, the closer you hold the viewfinder to the eye, the more of the landscape will be framed, and the further away you hold it, the reverse will be true.

I usually make several quick, exploratory sketches to help me decide which is the most promising composition. The amount of drawing necessary will depend upon the complexity of the scene and upon your own experience – with growing confidence you will need less. Sketch lightly, avoiding hard, uncompromising lines, particularly of natural objects such as trees. These are far better described by free, lively brushwork, unfettered by tight, constricting outlines. Never start by drawing directly on your watercolour paper – the inevitable alterations and erasures will damage its vulnerable surface and compromise subsequent washes.

When working in the field, pay particular attention to the direction of light. We have all seen paintings in which the light seems to be coming from a variety of directions in different parts of the composition. This can easily happen when the painting has taken so long to complete that the position of the sun has changed appreciably. To avoid this danger, make a careful note of the positions of the various shadows in your preliminary sketch and then stick to them, so that all the shadows on the ground fall in the same direction in your painting. When sketching in shadows, notice how their form is affected by the surface over which they fall. This will not only make your shadows look more convincing but will help to describe the form of that surface.

I almost always begin by painting the sky, largely because its form and colour will influence directly every other part of the painting. I favour a bold, direct treatment and try to maintain this loose approach when tackling the scene below, so that the painting will hang together. It is all too easy to 'tighten up' when painting fairly detailed parts of a subject, but it is important to find ways of conveying convincing impressions without resorting to an excessive amount of painstaking detail.

For some subjects, for example a group of buildings, it is worth waiting until the sun is in the ideal position before beginning your sketch. This would be when some of the walls are in light and others are in shadow, thus creating a three-dimensional effect. If there are no tonal contrasts, the sketch, and the subsequent painting, will look flat and uninteresting.

Be on the look out, too, for interesting colours. It is all too easy to accept, uncritically, conventional notions of colour, so reject such preconceived ideas and rely on your own observation. If you look with an open mind you will identify colours other than green in foliage, and if you emphasise these, your work will immediately appear more vibrant and imaginative.

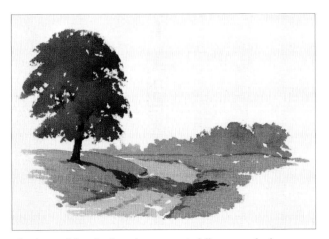

*The form of this shadow changes at it falls across the lane.*

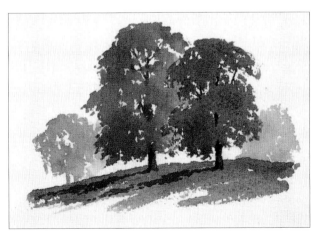

*Look for colours other than green in foliage.*

# Now for technique

Progress in watercolour painting depends largely upon mastering the various techniques involved. The most important are outlined here. All these techniques demand practice, but they are so vital to successful watercolour painting that they are well worth the effort.

## Washes

The first and most fundamental of watercolour techniques is the wash. A wash is simply a pool of liquid paint, prepared by thoroughly mixing one or more colours with water. The resulting tone will depend upon the proportion of water to paint. Test your washes on scrap paper for tone and colour, making allowance for the fading that always accompanies drying in this medium. There are various types of wash: flat, graded, variegated and broken. All can be used to good effect in landscape painting.

### Flat wash

The flat wash is the simplest of washes. Like other washes, it may be any size – large for sky areas, small for details in the landscape. It can be applied over broad areas by the simple process of preparing a large, well-mixed pool of colour and then applying it with successive horizontal strokes of a large brush right across the paper. Tilt your painting board at an angle of about fifteen degrees from the horizontal, so that the bead of liquid which forms at the lower edge of the brush stroke can be taken up by the following stroke. If the wash is correctly applied, the result should be a large area of smooth, uniform colour. If the paper is very absorbent, or if the application is somewhat hesitant and uneven, horizontal darker streaks may mar the evenness of the result. The best way to overcome this problem is to dampen the surface of the paper before applying the wash. If you do this, make allowance for the diluting effect of the damp surface by strengthening your wash.

*Flat wash*

*Graded wash*

### Graded wash

A variation of the simple wash is the graded wash. When you are about halfway down the paper, start to dip the brush into clear water instead of the prepared wash. The original colour on your brush will become progressively more dilute, producing a smooth gradation of the original colour to a paler tone. This is a useful technique for painting clear skies, where the blue always pales as it approaches the horizon.

### Variegated wash

A variation of the graded wash is the variegated wash. Here, a second colour is added to the brush, instead of clear water. This, too, is a useful technique for painting skies.

### Broken wash

A broken wash is useful if you are painting an area that has a somewhat rough surface, such as a field of hay. First prepare a pool of an appropriate colour and then apply it with swift, horizontal strokes of a large brush held almost parallel to the paper. The brush should skate over the surface of the paper, leaving chains of white dots in its wake where it has missed the little depressions in the rough finish. This technique naturally works better on a rough paper. Sometimes a little detail added to the broken wash will help to convey your message more effectively.

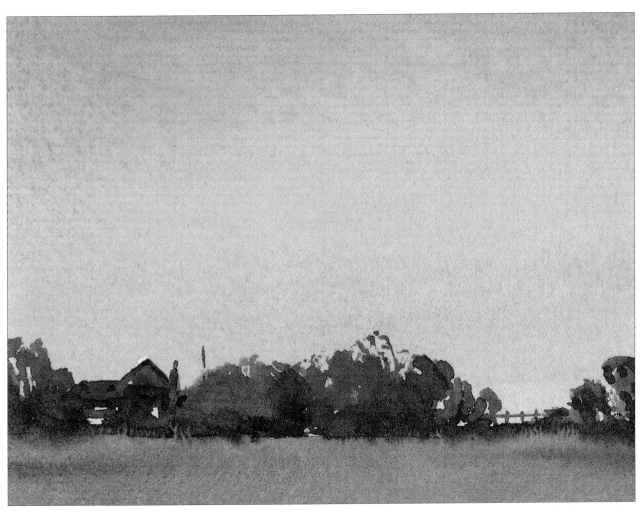

*A variegated wash effectively describes a clear sky.*

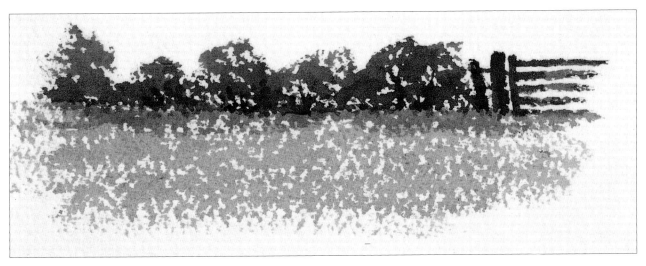

*A broken wash suggests a field of rough grass.*

# Wet-in-wet

Watercolour is the perfect medium for expressing the subtle effects of mist and fog, and here a technique known as 'wet-in-wet' enables you to capture the soft outlines that such conditions create. Suppose you wish to paint a misty woodland scene, with the outlines of the trees becoming ever more soft and ethereal with distance. The first step is to dampen the surface of the paper, perhaps with a pale wash reflecting the atmosphere of the subject. Any brush stroke you then apply to that damp surface will be soft-edged, and the wetter the surface, the softer the image produced. It therefore makes sense to paint the more distant trees first, in pale tones, then gradually strengthen your washes to deal successively with the nearer trees. As the underlying wash begins to dry, so the image produced, though still soft-edged, will become increasingly definite. Only when the initial wash is quite dry will they become hard-edged.

Two words of warning here: the second application of paint must be less liquid than the surface to which it is applied, or cauliflowering is bound to occur. Furthermore, if the underlying wash is too wet, any subsequent application of pigment will disperse and be virtually lost, leaving no discernible image behind. Timing, therefore, is vital and your judgement of timing will only come with experience.

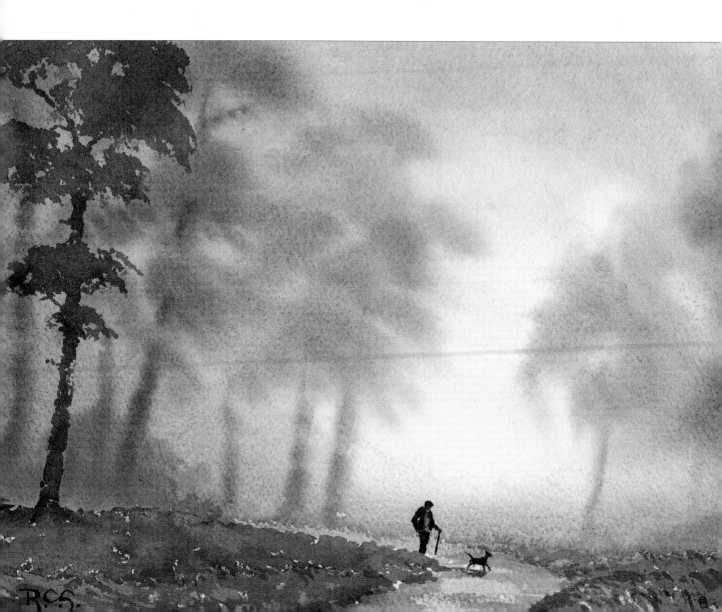

# Dry brushwork

Dry brushwork is another useful technique. Here you use rather less water in your wash and so the pigment is applied with a drier brush. This is a useful method of suggesting texture, and this technique also works better on a rough paper. A word of warning here: if the brush is too dry, the result will look dull and muddy.

*Dry brushwork can be used to suggest the rough texture of bark.*

# Splayed brushwork

Splayed brushwork is another technique that comes in useful when painting landscapes. The brush head is pinched at the point where the hairs enter the ferrule. This causes the hairs to fan out so that, when loaded with pigment, they may be used to paint clumps of foreground grass or reeds. It is a method that should be used with restraint, or a repetitive fringe-effect may result.

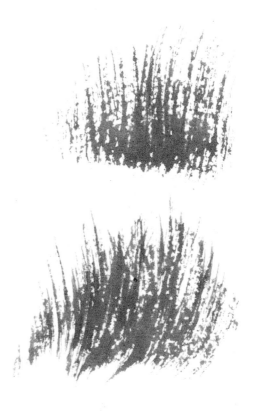

*These impressions of long grass were created using the splayed brushwork technique.*

*Opposite*
**Misty Woodland**
*310 x 230mm (12¼ x 9in)*
*The wet-in-wet technique is perfect for capturing misty landscapes.*

# Country Landscape

In this demonstration I put into practice some of the techniques described in the previous chapter. These include the variegated wash, the flat wash, the broken wash, wet-in-wet, dry brushwork and using masking tape. My subject is a Lakeland scene.

1. Sketch in the essential elements of the scene using a 2B pencil. Mask the boat sails using small triangles of masking tape.

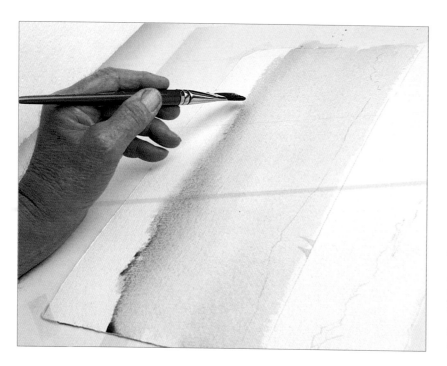

2. Mix up washes of raw sienna with a touch of light red, and ultramarine with a touch of light red. Wet the sky area with water using a 25mm (1in) flat brush. Turn the paper upside down and apply the first colour to the area just above the horizon. While the wash is still wet, introduce the second colour to create a variegated wash. Leave to dry.

3. Turn the paper the right way round. Use a No. 10 round brush and a flat wash of French ultramarine with a little light red to paint in the mountain range. Leave to dry.

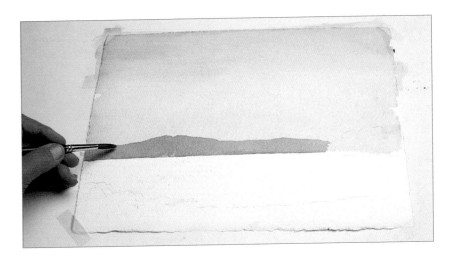

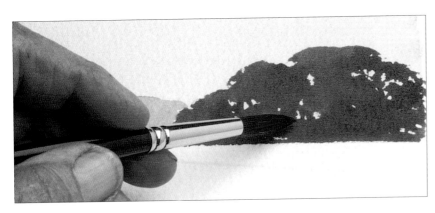

4. Mix raw sienna, a little burnt sienna and Winsor blue, then use a No. 10 round brush on its side to create a broken wash for the middle distance trees. Leave to dry.

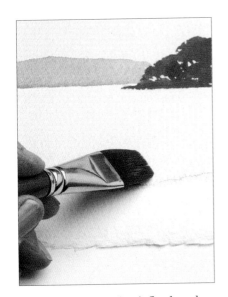

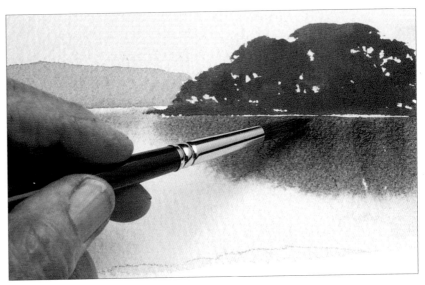

5. Use a 25mm (1in) flat brush and the same washes as in step 2 to paint the reflection of the sky in the water.

6. While the water area is still wet, use a No. 10 round brush and the same colours as in steps 3 and 4 to put in the reflections of the mountains and trees. Leave a pale strip to suggest an area of disturbed water. Allow to dry.

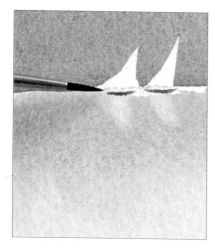

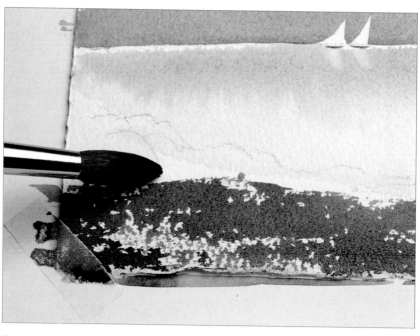

7. While the wash is still wet, use a clean, dry brush to lift out a little of the colour from the water area to create the reflections of the sails. Leave to dry, then remove the masking tape. Use a No. 2 round brush and burnt sienna with a touch of French ultramarine to paint in the hulls.

8. Use a No. 8 round brush and a broken wash of burnt sienna and French ultramarine with a touch of raw sienna to paint in the shingle foreshore. Use the brush on its side with quick horizontal strokes to create texture.

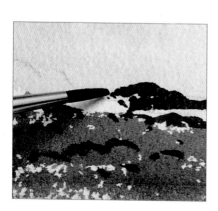

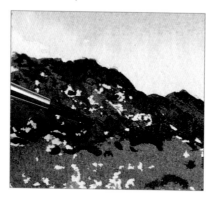

9. Add Winsor blue to the previous wash and use the tip of a No. 8 round brush to add detail to the foreground. Leave to dry.

10. Use a No. 6 round brush on its side with just a little paint on it (raw sienna, burnt sienna and a touch of Winsor blue) to suggest more texture on the foreground rocks. Leave to dry.

11. Use a 12mm (½in) flat brush to apply a pale wash of raw sienna, burnt sienna and a touch of Winsor blue over the foreground area.

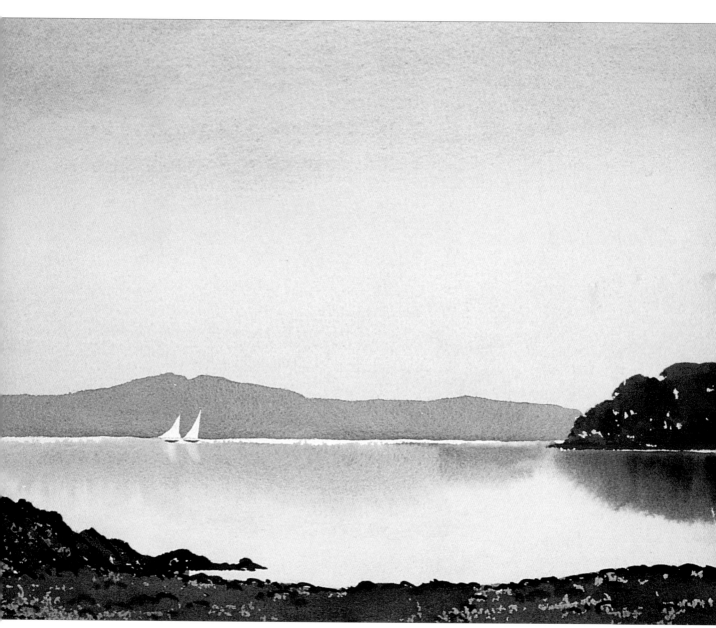

*The Finished Painting*
*375 x 280mm (14¼ x 11in)*

# Lively skies

As you have already seen, freshness and translucence are of vital importance in watercolour painting and this applies with particular force to the treatment of skies. You should therefore do all you can to preserve these desirable qualities and aim to create an impression of light and movement. The old adage, plan like a tortoise, paint like a hare is worth remembering in this context!

The variegated wash (see page 18) is ideal for rendering cloudless skies. For this you must prepare two washes, one for the pale, warm tones just above the horizon and the other for the stronger blues higher up in the sky. You do not always have to match exactly the colours of nature and some of the more brilliant Mediterranean blues should be understated in the gentle medium of watercolour. At the same time you must remember that watercolour fades on drying and you should allow for this when mixing your washes.

When painting clouds, I often use washes which blend to produce soft edges, but I like to preserve a few hard edges for the sake of variety. The painting below shows a sky painted in this manner. An alternative method of painting cloudy skies is to wet the whole of the sky area first, perhaps by applying a variegated wash, and then to drop in colours for the

*Loch Long, Wester Ross*
*375 x 275mm (14¾ x 10¾in)*

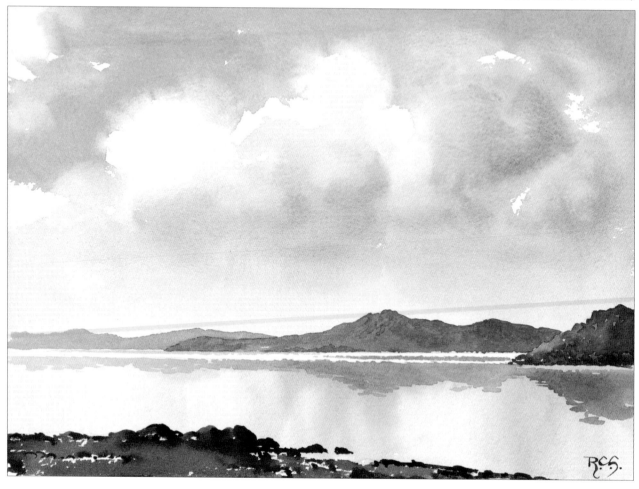

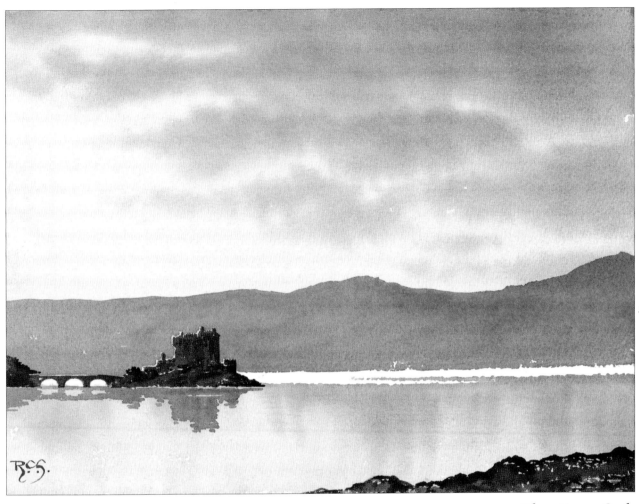

*Eilean Donan Castle*
*370 x 275mm (14½ x 10¾in)*

clouds, wet-in-wet. With this method, all the edges are soft, to produce a smooth, overall effect. The sky in the painting above, was painted in this way. Notice how the light red has separated from the French ultramarine to give the clouds a warm halo. The level formations of stratus clouds give skies a settled, peaceful appearance and are useful if this is the message you want to convey in your painting. They may be painted with bold, horizontal strokes of a large brush, either wet-on-dry, if you want crisp edges, or wet-in-wet if you prefer a softer image.

Skies become more exciting from the artist's point of view when there are interesting cloud formations and here some knowledge of the main cloud types is helpful. With all types of cloud,

observation and conscientious practice are the dual keys to success. The four main categories are listed here, but there are also various in-between formations, such as cumulo-nimbus and cirro-stratus.

• **Cirrus** These are the high altitude, fluffy, white clouds composed of frozen water vapour.

• **Stratus** As the name suggests, these clouds form smooth layers which can cover the whole sky or part of it.

• **Cumulus** These are the billowing clouds with high, domed crests and level bases.

• **Nimbus** These are the storm clouds, often heavy and dark in tone, with broken, ragged edges.

# Cumulus Clouds

Cumulus clouds are, in my view, the most paintable of all. There is no need to draw the cloud outlines first, and most artists are happy to go straight in with the brush. At the same time, you should have some idea of the overall shapes, or you may unthinkingly end up with two or three clouds of almost the same shape and size.

Begin by preparing three washes: one for the warm tones lower in the sky, the second wash for the cloud shadows and the third wash for the blue of the sky. The order in which these washes are applied is a matter of personal choice. I usually start with the pale wash for the lower sky, mainly because I then dilute it for the areas of sunlit clouds, which go in next. I then put in the cloud shadows, to the undersides of the clouds and the sides away from the source of light, and finally apply the blue wash, which helps to delineate the upper shapes of the clouds.

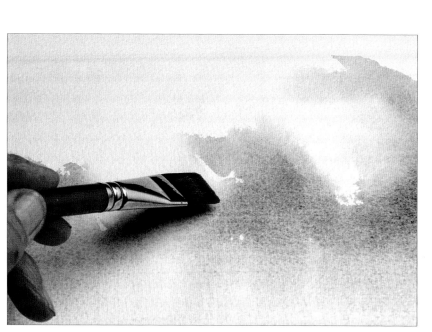

1. Use a 25mm (1in) flat brush to apply a wash of raw sienna mixed with a touch of light red above the horizon. Dilute this colour with a lot of water and use this to paint in the sunlit area of the clouds. Use a wash of ultramarine and light red to paint in the cloud shadows. The grey of the cloud shadows tends to be warmer just above the horizon and cooler higher in the sky, so adjust the proportions of ultramarine and light red in your washes accordingly.

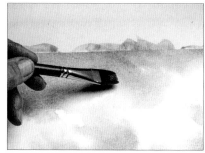

2. Use ultramarine with just a touch of light red for the blue of the sky.

*Note* As you are painting the sky, use a 12mm (½in) flat brush to soften some edges with water, but leave others hard.

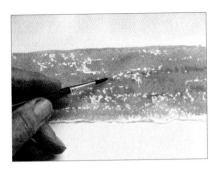

3.  Paint in the grass in the foreground using a No. 12 round brush and a broken wash of raw sienna with a touch of Winsor blue. Add texture using the same colour and a No. 6 brush.

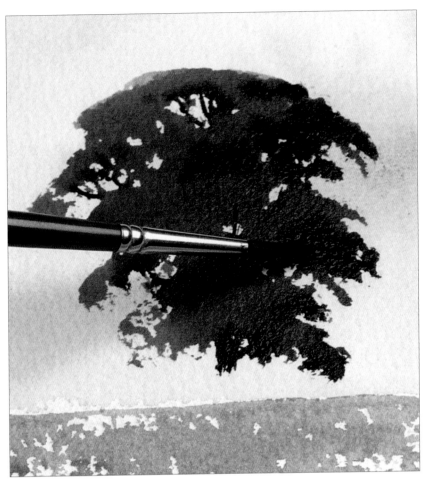

4.  Use a No. 10 round brush with raw and burnt sienna and Winsor blue in various proportions to paint in the tree. Add shadows with a No. 6 round brush, using a deeper mix of burnt sienna and Winsor blue.

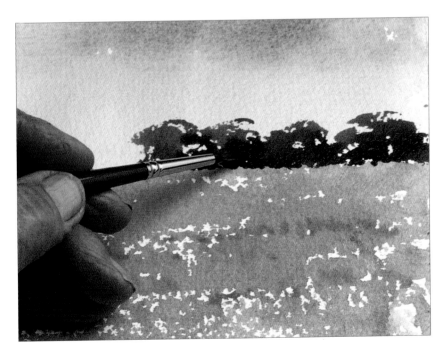

5.  Paint in the hedge using a No. 10 round brush and the same colours as in the previous step. Use a No. 6 round brush to add a little shadow underneath as you work. Remember to leave a gap for the gate.

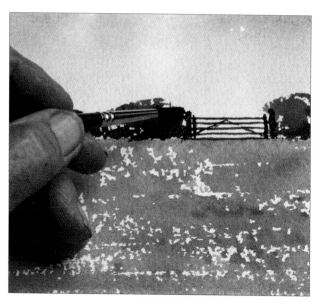

6. Paint in the gate using a No. 6 round brush and a mix of burnt sienna and Winsor blue.

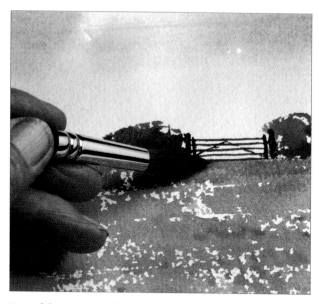

7. Add more shadows underneath the hedge using a No. 10 brush with a mix of burnt sienna and Winsor blue.

**The Finished Painting**
*380 x 275mm (15 x 10¾in)*

30

# Water and reflections

Light reflected in smooth water can enliven the dullest landscape but you must strive to do it full justice by portraying it in clear, fresh washes. Light reflected in water also serves the useful function of linking the sky to the scene below. To capture the full beauty of reflected light, you need to make it appear to shine. This can be done partly by using pale-toned washes and partly by placing deep-toned passages alongside, to provide contrast.

Problems can arise in certain conditions when the breeze fragments the surface into thousands of minute ripples, creating a mass of detail that no watercolour technique can describe without excessive overworking and consequent loss of

freshness. The only answer to this problem is to view the reflections through half-closed eyes, so that the tiny details merge together to produce a smooth pattern which a wet-in-wet technique can suggest economically and effectively. It sometimes happens that the breeze will itself soften the reflections in this manner, to make your task simpler.

Speed is all-important when painting wet-in-wet reflections, as the desired effect will be lost if premature drying occurs. It is vital, therefore, to study the colours and tones you need and prepare your washes in advance. My method is to apply one

*Willow Stream*
*375 x 270mm (14¾ x 10½in)*

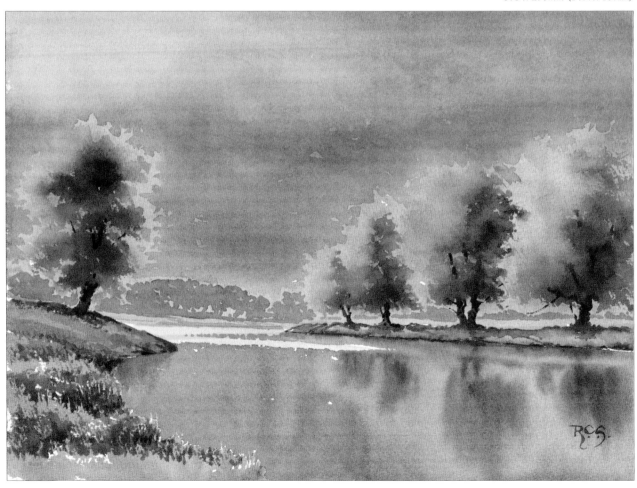

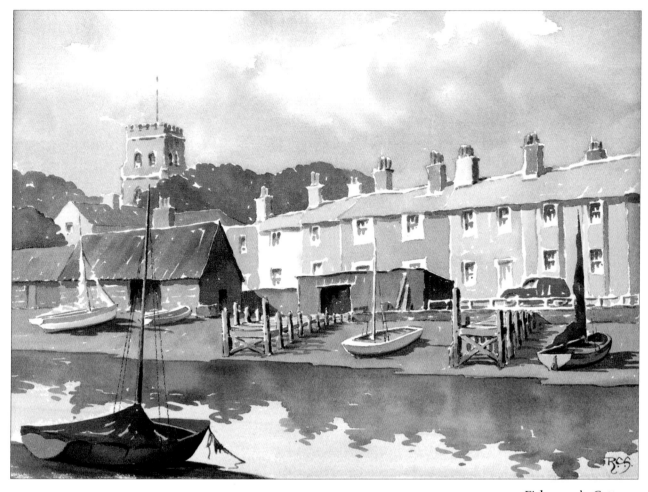

*Fishermen's Cottages*
*390 x 280mm (15¼ x 11in)*

or more pale washes, approximating to the colour of the reflected sky, to the whole of the water area. I then use vertical brush strokes to drop in the various reflections, wet-in-wet, using the washes already prepared. A few darker accents, still soft-edged, will complete the picture. This technique is illustrated in the painting opposite.

If your chosen subject is complicated, anything approaching a mirror image reflection will result in an over-busy painting, with the reflections competing with the scene above instead of complementing it. In such a situation I would opt for soft-edged reflections whatever the conditions.

Hard-edged reflections also need careful study before you put brush to paper. Here again, I usually begin by applying a pale wash or washes to the

whole water area, but then allow drying to take place before putting in the reflections of the objects above. Some simplification is necessary or the reflections can become over-complicated. It sometimes helps to make the whole area of the darker reflections hard-edged while using a wet-in-wet method within the darker area, a technique used in the painting above.

The main difficulty in painting water arises from the fact that, unless the surface is absolutely still, the pattern of the reflections is continually moving and changing. What you must do, after careful study, is to freeze an instant of time in your mind's eye and then paint partly from memory. As with so much in art, this requires careful observation and plenty of practice, but the results will reward the effort.

# Scottish Loch

In this demonstration painting of a Scottish loch, I show how I use hard-edged reflections to suggest the rippling surface of the water. There is quite a lot to remember when painting ripples! Not only do you have to bear in mind their colour, which must relate to that of the area being reflected, but you have to give your wash an irregular indented edge to represent the ripples.

**What You Need**

Paints:
   Raw sienna
   Burnt sienna
   Light red
   French ultramarine
   Winsor blue
Brushes:
   25mm (1in) flat
   No. 8 round
   No. 10 round
   No. 12 round
Other materials:
   Paper: Not or Rough, 200lb (425gsm) or over – or under 200lb (425gsm) if stretched
   2B pencil

1. Sketch in the essential elements of the picture. Lay in the main sky area using a 25mm (1in) flat brush and raw sienna with a touch of light red. Use the same colour, but much diluted, for the sunlit area of the clouds. Use a mix of ultramarine and light red for the cloud shadows. Finally, add a wash of ultramarine with just a touch of light red for the blue of the sky. Leave to dry.

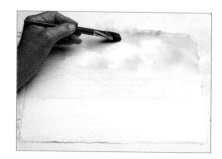

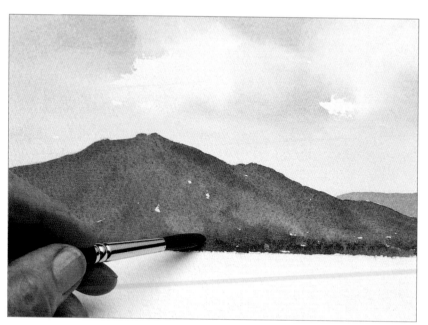

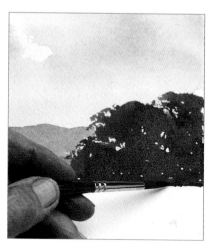

2. Paint in the mountains using a No. 10 round brush. Use raw and burnt sienna for the lighter areas of the main mountain, and ultramarine and light red for its shadows. Leave to dry, then use a lighter version of this last mix for the distant mountains. Add a mix of burnt and raw sienna with a touch of Winsor blue for the trees along the distant shoreline – this should be applied wet-in-wet. Leave to dry.

3. Paint in the middle distance trees using the side of a No. 10 round brush and varying proportions of raw sienna, burnt sienna and Winsor blue. Add shadow with a No. 8 round brush. Leave to dry.

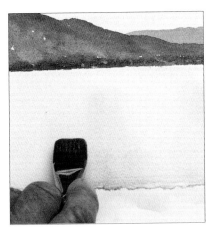

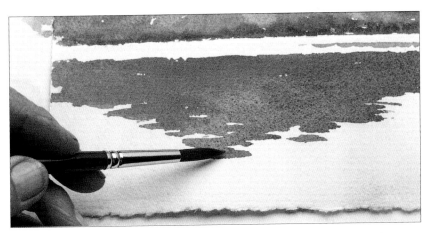

4. Use a 25mm (1in) flat brush to paint in the water. Lay in washes with vertical strokes, in colours which roughly correspond to the sky area above. Leave to dry.

5. Paint in the reflections in the water using all three round brushes. Use raw sienna, burnt sienna and Winsor blue for the reflections of the sunny parts of the mountains. Use French ultramarine and light red for the reflections of the shadows on the mountains. Leave a pale, untouched strip to suggest a band of wind-ruffled water – this serves the useful purpose of separating the distant scene from its reflection.

*The Finished Painting*
*370 x 255mm (14½ x 10in)*

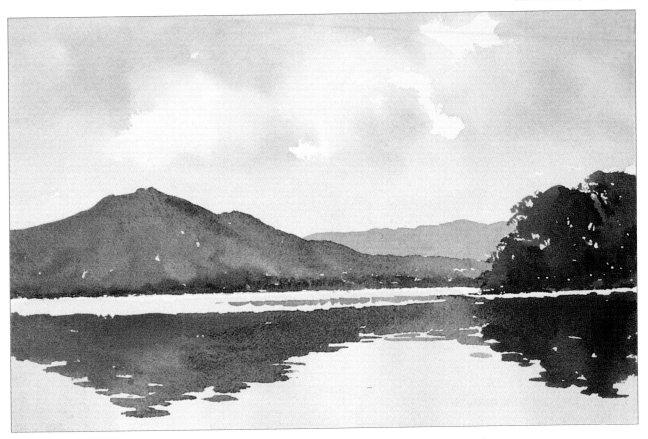

# Farm Pond

On perfectly still days reflections are virtually mirror images, while the presence of wind causes rippling. Slight breezes frequently produce a softer effect. Here, the conditions are such that the reflections in the pond are soft-edged and I demonstrate how I use the wet-in-wet technique to obtain the desired effect.

**What You Need**

Paints:
   Raw sienna
   Burnt sienna
   Light red
   French ultramarine
   Winsor blue
   Payne's gray

Brushes:
   25mm (1in) flat
   No. 8 round
   No. 10 round
   No. 12 round

Other materials:
   Paper: Not or Rough, 200lb (425gsm) or over – or under 200lb (425gsm) if stretched
   2B pencil

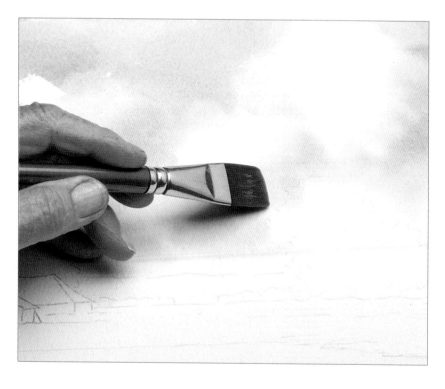

1. Sketch in the essential elements of the picture. Lay in the sky using the same colours and brushes as shown in step 1 of the Scottish Loch demonstration on page 34. Leave to dry.

2. Paint in the roofs of the buildings using various combinations of light red and burnt sienna, each mixed with a touch of French ultramarine. Use a No. 10 round brush to put in the main body of colour and a No. 8 round brush to add detailing. Use raw sienna and a touch of Winsor blue to suggest moss; burnt sienna for the brick building; and burnt sienna and French ultramarine for the wooden building. Leave to dry then put in a few texturing strokes, following the slope of the roofs. Leave to dry.

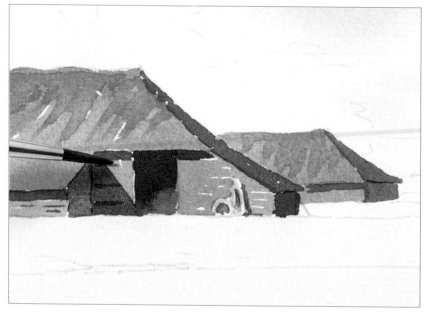

3. Paint in the trees and hedges with a No. 10 round brush, using varying combinations and strengths of raw sienna, burnt sienna and Winsor blue. Use a No. 8 round brush to lay in the shadows. Leave to dry.

4. Lay in the distant hills using a No. 8 round brush and French ultramarine mixed with light red. Paint in the foreground grass using a No. 12 round brush and a broken wash of raw sienna mixed with a little Winsor blue. Add a little Payne's gray and burnt sienna, then paint in the shadowed areas and the gate with a No. 8 round brush. Leave to dry.

5. Use a No. 10 round brush to paint over the entire pond with the colours used for the sky, to give a pale background. Add vertical strokes, wet-in-wet, for the reflections of the trees and buildings. Finally, add a few dark accents.

*The Finished Painting*
*375 x 270mm (14¾ x 10½in)*

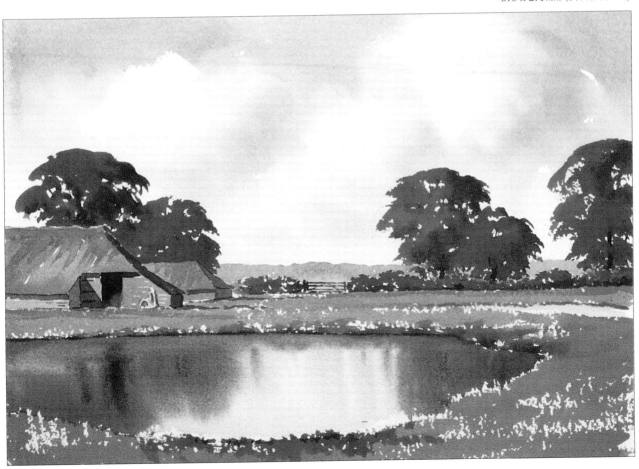

# Trees and foliage

Of all the elements in the landscape, trees probably cause the inexperienced painter the most difficulty. This is particularly true when they form part of the foreground and are close enough for the mass of leaves and twigs to be seen in intricate detail. Any attempt to represent every leaf by an individual dab of paint is doomed to failure for the result would look impossibly overworked and monotonous. The most effective answer to the problem is to view the subject through half-closed eyes so that detail is lost and the foliage is seen to be made up of areas of varying tone and colour which are amenable to watercolour interpretation.

I find the best way of capturing the ragged outlines of trees in full leaf is to hold the brush almost parallel to the paper so that the side rather than the tip produces the image. This technique works best on rough paper, but is perfectly possible on Not. The side of the brush comes into contact with the little bumps in the paper's surface but misses the depressions, thus creating the desired broken outline. The procedure is this: first prepare two washes – the first for the colour of the sunlit foliage, the second for the foliage in shadow. Load the brush with the first wash and apply it, as described, with the side of the brush – concentrate not only on producing the broken outline of the foliage, but also on the overall shape of the tree. When the first wash is complete but still moist, apply the second, deeper-toned wash, wet-in-wet, to the side of the tree away from the source of light and also to the undersides of the branches.

This approach is not quite as easy as it sounds, but with practice you will learn to paint trees convincingly and economically. Avoid making your trees too solid by trying to incorporate some of the sky holes through which sections of branch and trunk are often seen.

Winter trees present rather different problems, though the need to simplify complex forms is just as necessary. Beginners often have difficulty with branches pointing forward or away, and content

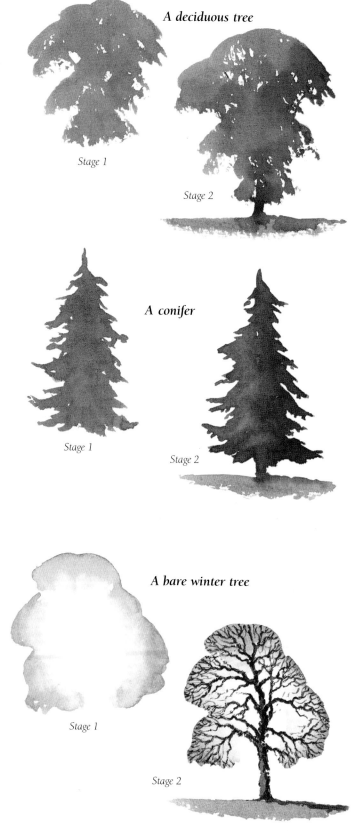

*A deciduous tree*

*Stage 1*

*Stage 2*

*A conifer*

*Stage 1*

*Stage 2*

*A bare winter tree*

*Stage 1*

*Stage 2*

themselves with painting just the laterals! The only answer here is closer observation and practice. If you study the mass of twiggery at the ends of the branches, the need to simplify becomes obvious. Some painters use a dry brush technique to capture its effect, others, after the style of Rowland Hilder, prefer to use a pale wash to represent the twigs and the sky beyond. Try both methods and see which suits you best.

# Colour

Most ready-mixed greens often contain too much blue for foliage use, and many painters therefore prefer to mix their own. I often use raw sienna with a little Winsor blue, or, for a duller effect, Payne's gray, sometimes adding burnt sienna for a little warmth. Always analyse the colour of the trees you are painting and do not accept uncritically the convention that they are just green. Look for the warmer colours – oranges, yellows and browns – and make the most of them. This will not only call attention to colours the casual observer is likely to miss but will add interest and variety to your work. These warmer colours are most apparent, of course, in the autumn months but hints of them are usually present earlier in the year. If they need a little emphasis or even exaggeration, so be it!

For more distant foliage, cool blues and greys replace the warmer greens. Tonal contrast is greatly reduced or lost altogether, so that a bank of distant trees may well be represented by a flat wash, perhaps of French ultramarine with a little light red. Trees in the middle distance are far enough away for detail to be lost and so also lend themselves to simple, painterly treatment.

# Shadows

The shadows in trees demand careful scrutiny. Do not be content with just a darker version of the green you are using for the body of the tree, and look for traces of blue, purple and other colours which are also there. Tree trunks, too, repay careful observation, with subtle greys and greens more in evidence than the conventional brown. Study the shapes of the shadows falling on the trunks, and ensure your treatment reinforces their cylindrical form. Remember that trunks are usually in deep shadow as they emerge from under the mass of foliage.

# Hedgerows

The techniques I have described may be applied with equal success to the painting of hedgerows. If the landscape is undulating, pay particular attention to the line of the hedges, to ensure they follow the slope of the ground on which they are situated and do not cut across it.

*A hedgerow*

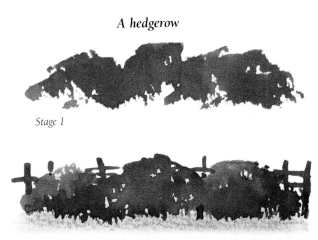

*Stage 1*

*Stage 2*

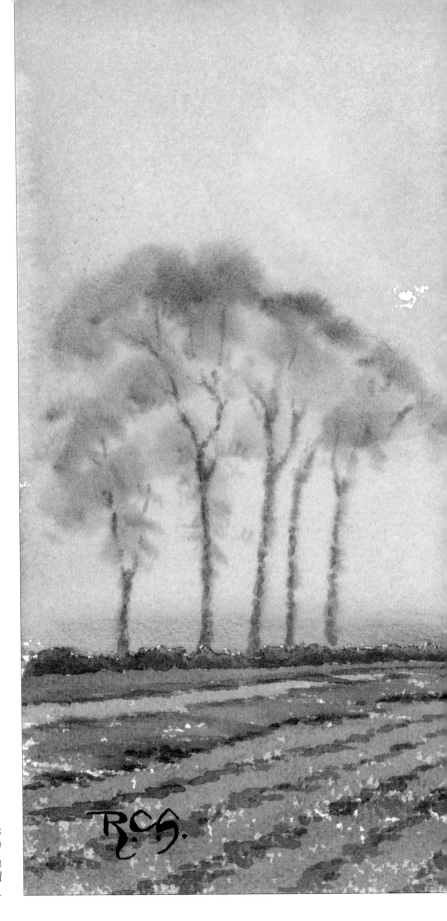

**Autumn Fields**

*370 x 275mm (14½ x 10¾in)*

*This painting illustrates how a
convincing landscape may be produced
using very little green.*

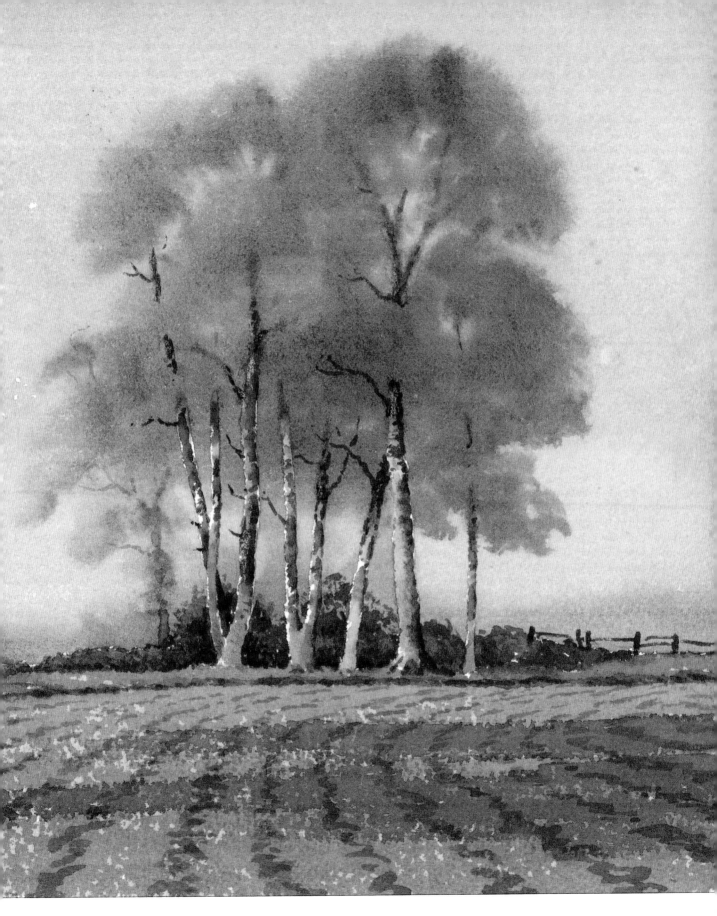

# Buildings

Cottages and farms are an integral part of the rural scene and should receive just as much thought and consideration as any other part of the landscape. Indeed, their geometric form requires rather more forethought than that of natural features such as trees and foliage. For example, a building seen head-on rarely has the same appeal as a more oblique view, with some walls in light and some in shadow. Similarly, a group of farm buildings strung out in a straight line makes a far less appealing subject than the same buildings seen from a different viewpoint, so that they overlap and form a cohesive and more interesting group. The buildings in the painting below are an example of this sort of treatment.

These are considerations you should always bear in mind when planning a composition.

Old buildings have a special attraction and by their very age become almost part of the natural scene. You should aim to emphasise their venerable character, perhaps by stressing their wayward lines and by exaggerating any signs of weather-staining. They present the same sort of detail problems as any other element in the landscape – when they are close enough to enable us to see every brick and tile individually, just how much detail should we put in? The answer has to be just sufficient to identify

*Farm Lane*
*380 x 280mm (15 x 11in)*

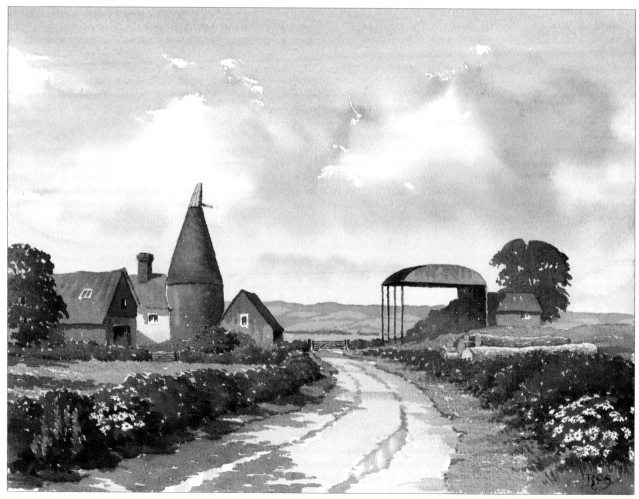

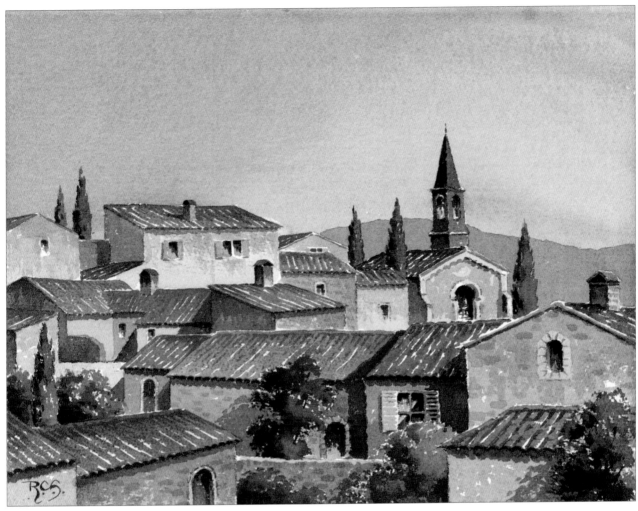

*Roofscape, La Roque*
*380 x 280mm (15 x 11in)*

the nature of the building materials – a few small areas of brickwork or a few random stones will provide sufficient information and the rest can safely be left to the imagination. The sketch shown here is an example of this sort of treatment.

Buildings are often part of a rural landscape, but they obviously predominate in cities, towns and villages. Such scenes have just as much right to be described as landscapes and often offer excellent subject matter for the perceptive artist. I believe that you should at all times aim to keep an open and enquiring mind and respond to artistic stimuli whenever you encounter them. You will then see possibilities in the most unlikely places, often on your own doorstep. Stanley Spencer and Lowry drew their inspiration from their own environments, one with his Thames-side settings, the other with his interpretations of industrial Lancashire, and you would do well to follow their example.

It sometimes pays to look for an unusual angle or viewpoint, to bring a touch of originality to a conventional or even mundane scene. The painting above, is an example of this, and here the high vantage point facilitated the development of the pattern of pan-tiled roofs.

43

Look for tonal contrast wherever it exists and, within reason, move the constituent parts of the scene so that lights and darks are placed side by side. Notice the important part played by the shadows in the painting featured here.

Those parts of buildings usually seen against the sky, such as tall gables and chimneys, always look dark by contrast with their pale background and should be painted in correspondingly deep tones. Windows deserve more care than they frequently receive and should not be rendered simply as uniform grey oblongs. Sometimes there is a glimpse of curtain, sometimes there is reflected light and sometimes there is just the dark interior – and often a mixture of all three. Ring the changes to produce variety. I am not, however, advocating minute attention to detail – windows, like any other architectural features, can be effectively suggested by a loose technique.

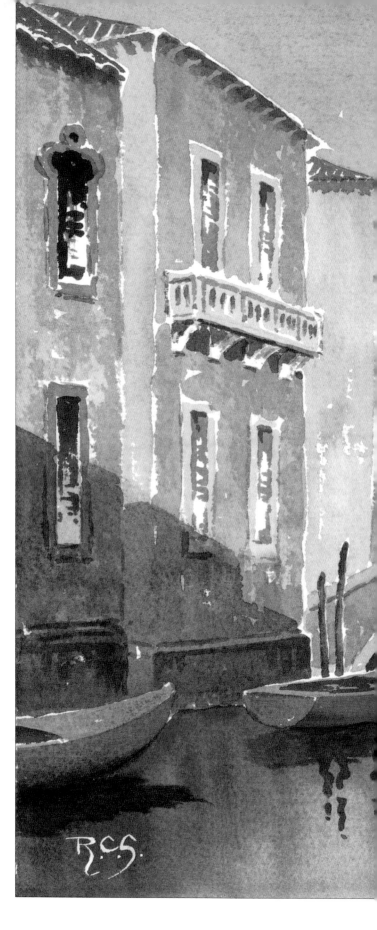

*Evening in Venice*
*375 x 285mm (14¾ x 11¼in)*

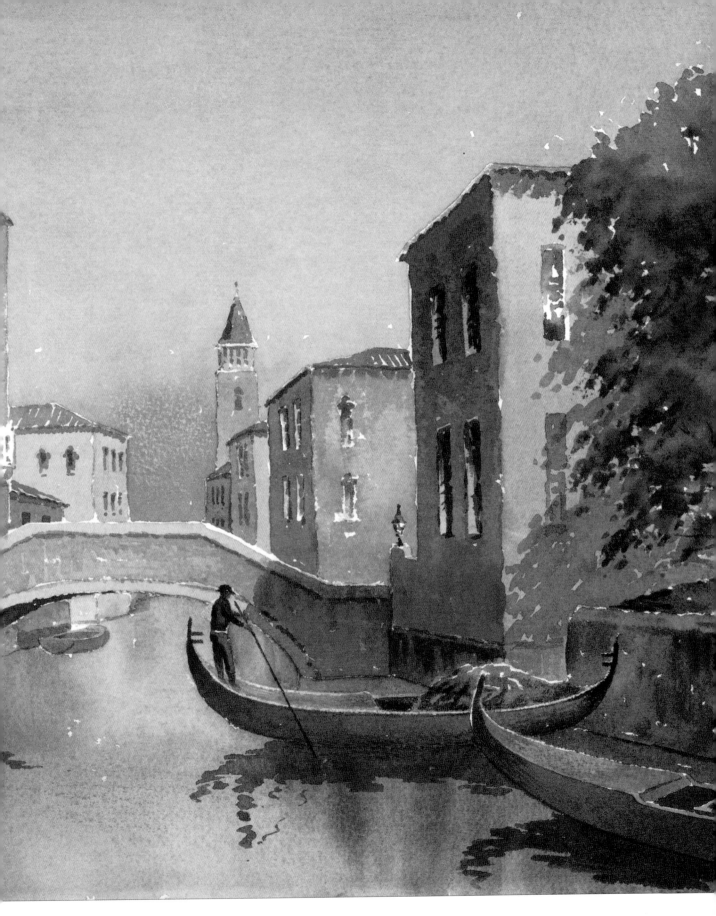

# Painting people

The question of whether or not to include the human form in a painting must depend largely upon the subject of that painting and the mood which the artist wishes to create. In grim moorland vistas, storm-lashed coastlines and the like, the presence of figures would destroy the feeling of lonely desolation and much of the impact would be lost. In such scenes as street markets, village greens and busy boat yards, however, the reverse is true and here the absence of people would completely wreck the impression of bustling activity. Between these two extremes, the decision is less clear-cut and the artist has to weigh up the pros and cons.

On the credit side, the human figure can make an excellent focal point, and in the absence of another obvious candidate is well worth considering. It can also provide scale in situations where there is no clear indication of size, and, of course, it can add interest to a painting.

On the debit side, the inclusion of a figure that is ill-drawn and wooden does far more harm than good. This does not, however, disqualify all those who have not studied human anatomy in depth: figures in the landscape are usually small and, with practice, you can learn to paint them reasonably convincingly. The secret is to concentrate on posture and seize every opportunity for making sketch book studies. These will not only help you improve your standard, but will provide you with sketches of a wide variety of human figures in many different postures, for use on those frustrating occasions when a figure is needed in a landscape painting, and none is in sight.

The looser the treatment, the less precision required. Groups of people, viewed at some distance, can, for example, often be effectively suggested by multi-coloured dabs of paint. Have fun making lightning impressions of unsuspecting subjects – the practice and the resulting sketches will stand you in good stead.

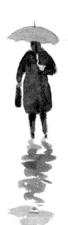

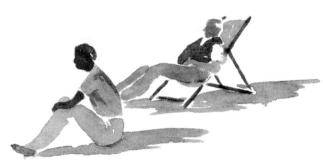

# The way forward

I hope that by the time you reach this page you will have decided to avoid overworking and labouring after detail with their attendant tired and muddy results, and will be determined to realise the full beauty and potential of watercolour by painting boldly with full, fresh washes. Success will not come immediately but if you stick to the principles outlined, you will be on the right road. There will be inevitable failures, but you really will learn from your mistakes, however depressing, and if you conscientiously analyse the reasons for failure, this too can be a valuable part of the learning process.

I have been primarily concerned with watercolour technique in this book because without it you will never be able to express yourself fully or effectively. However, it is worth remembering that technique is only a means to an end and not an end in itself. Never allow it to crowd out artistic vision and creativity, either in choosing your subjects or in interpreting them with feeling and imagination.

There is always the temptation to stick to subjects and treatments you know are within your compass and which are admired by your friends. Professional painters are under similar pressures from the galleries which handle their work – the proprietors know what sells readily and understandably want more of the same. Everyone is encouraged by public approval and by selling paintings, but if you are content to settle for this, your range of subject matter will become ever narrower and you will find yourself on a road that leads nowhere. So, be true to yourself, follow your own ideas and convictions with integrity and find your own way forward. *Bon voyage*!

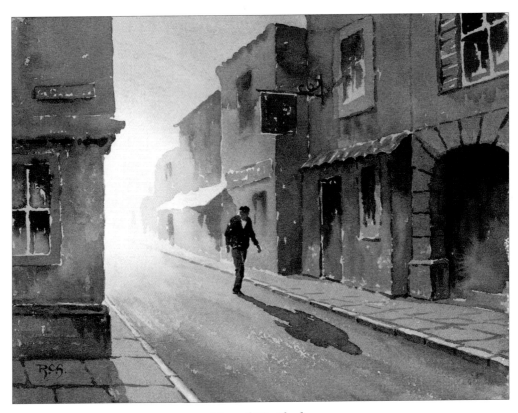

**Me and My Shadow**
*370 x 280mm (14½ x 11in)*

# Index

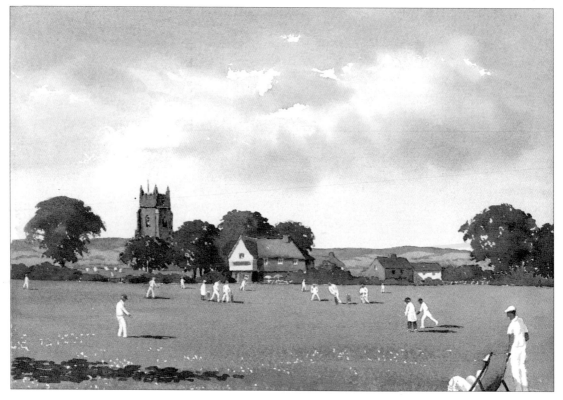

*Village Cricket*
*380 x 260mm (15 x 10¼in)*